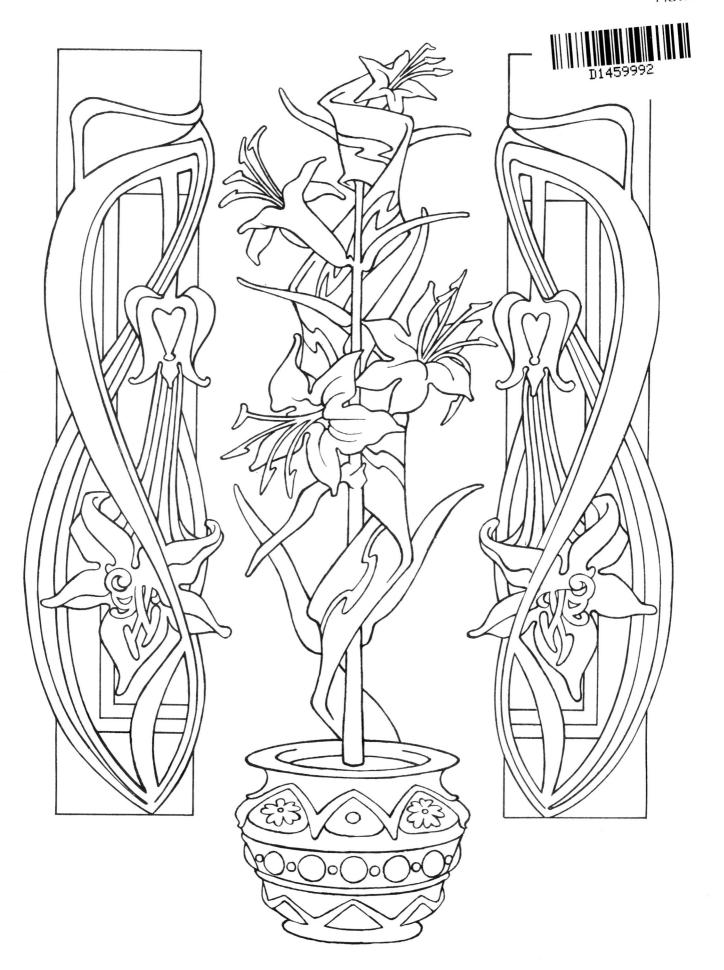

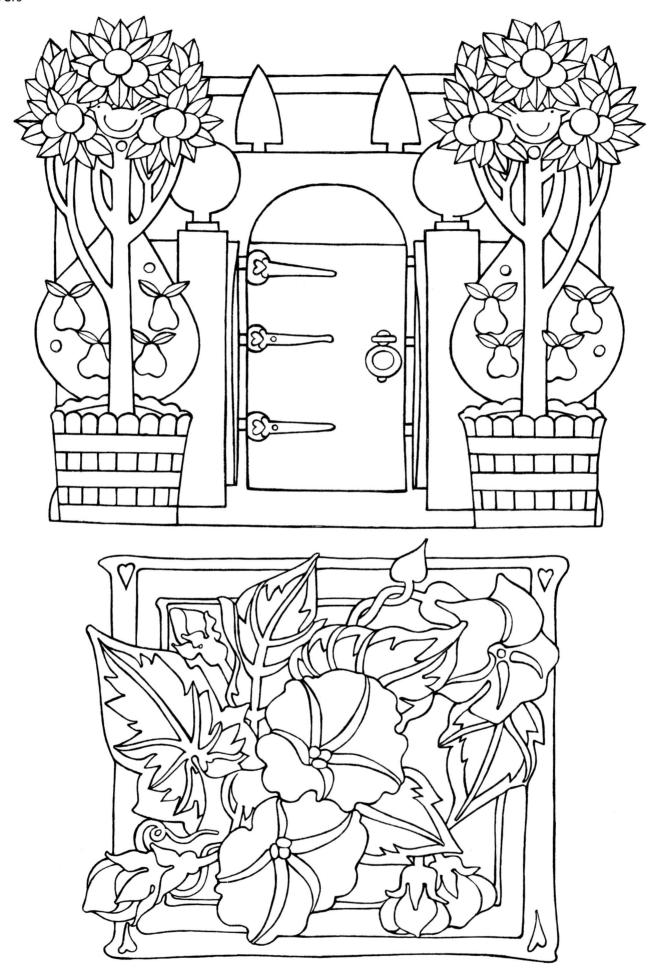

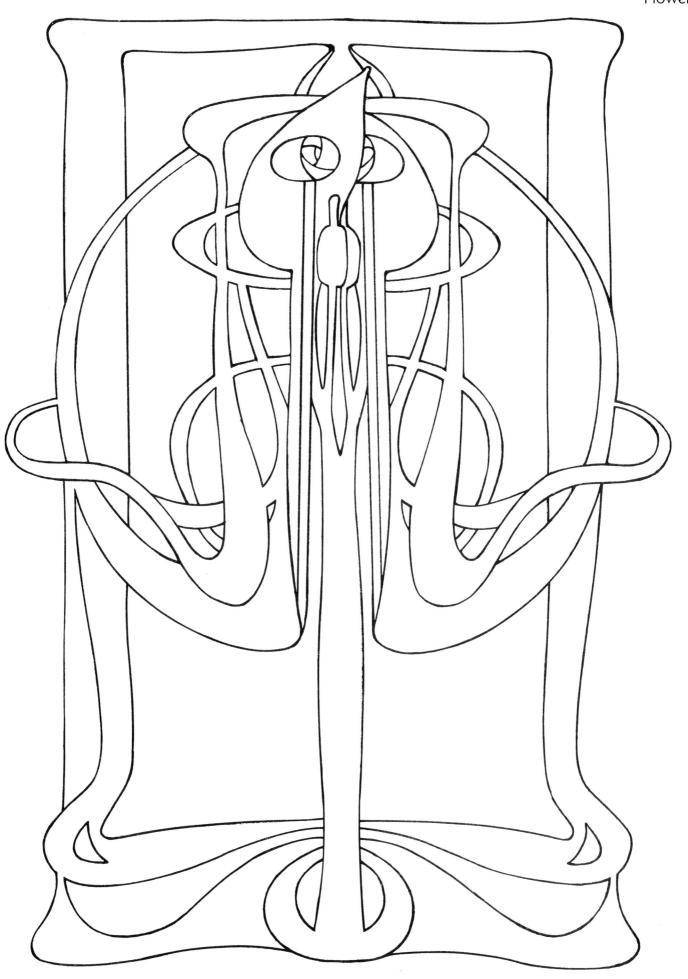

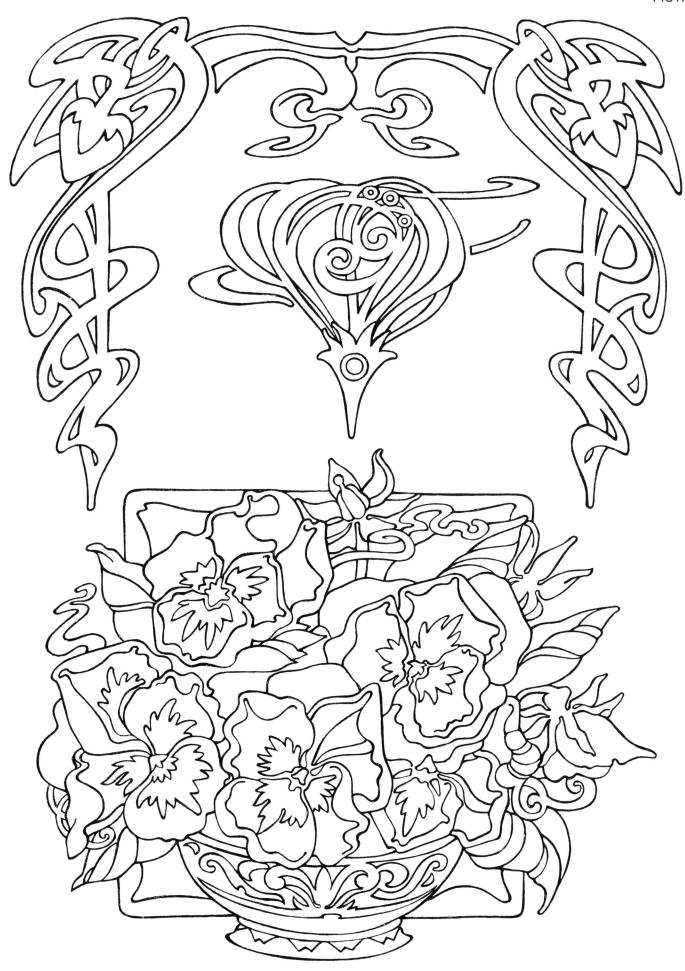

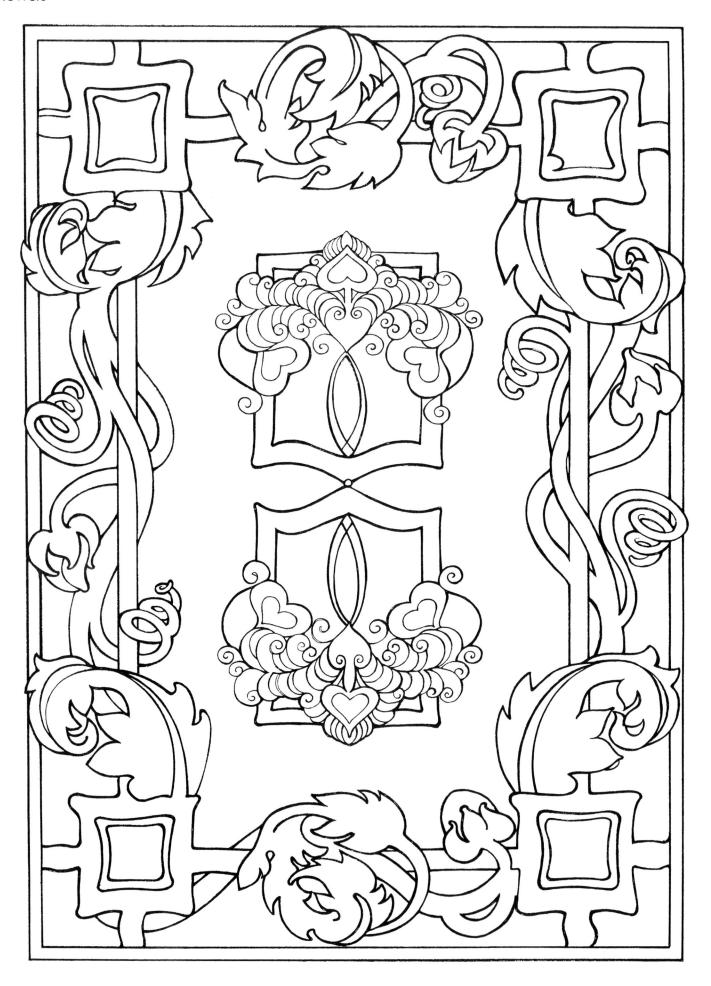

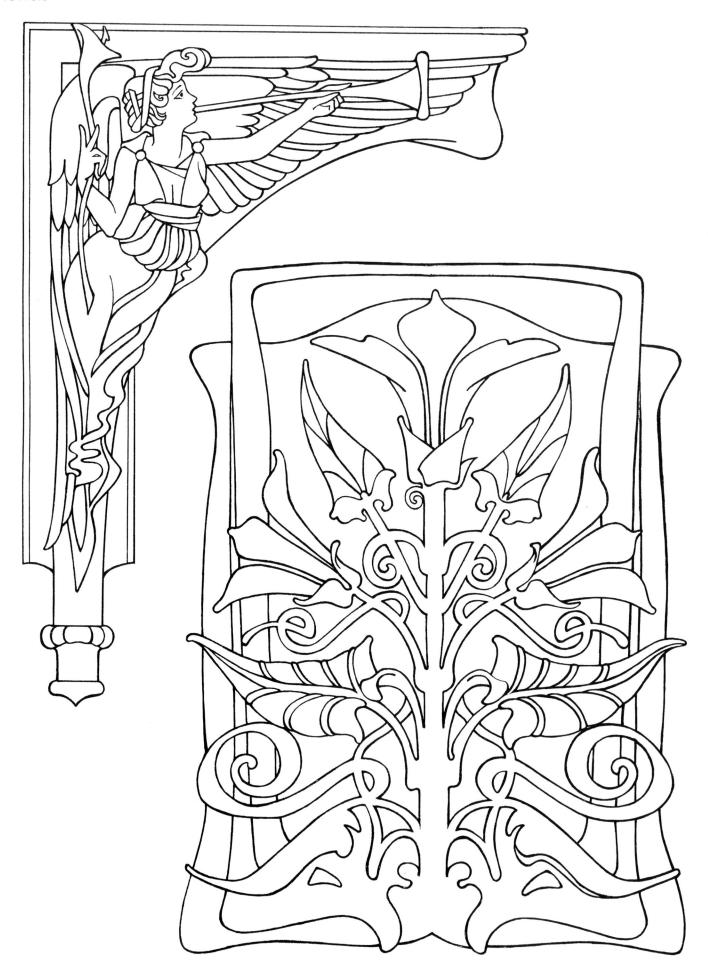

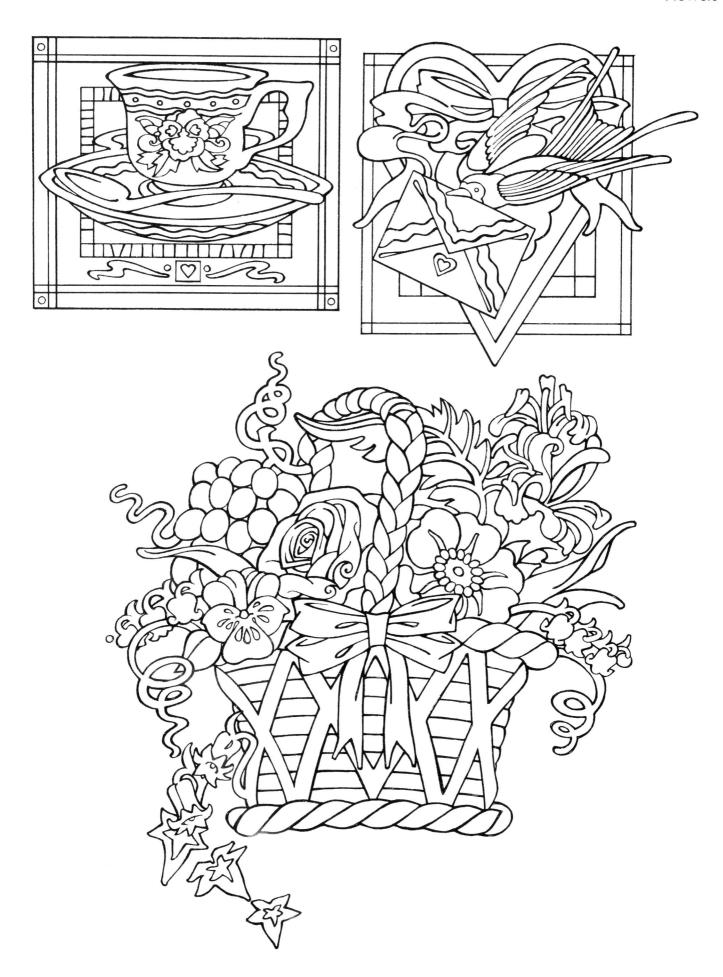

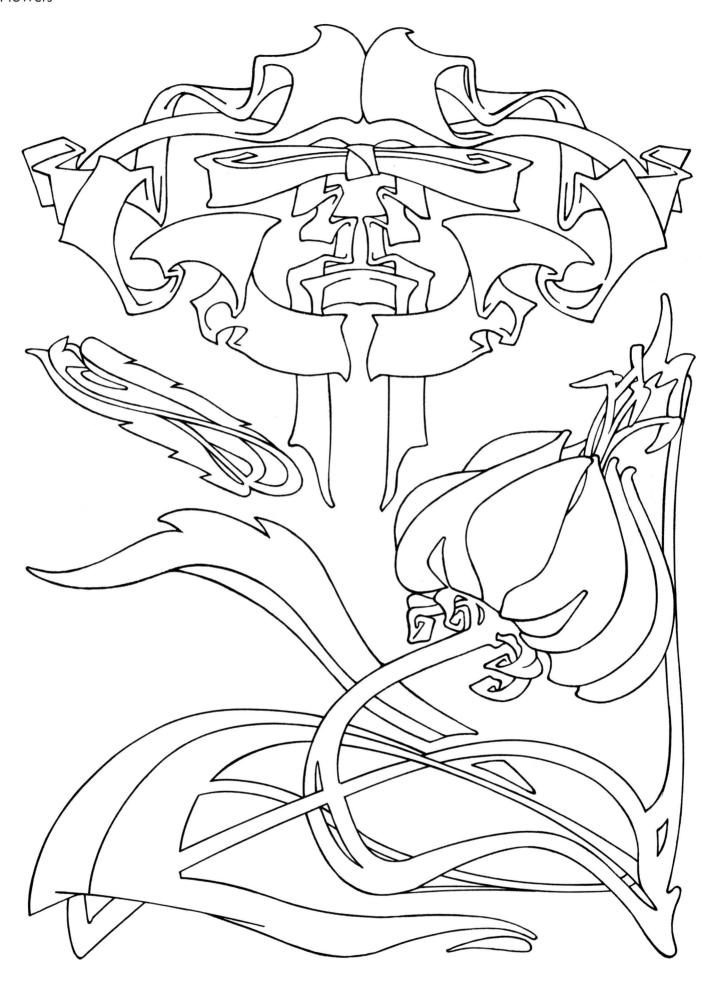

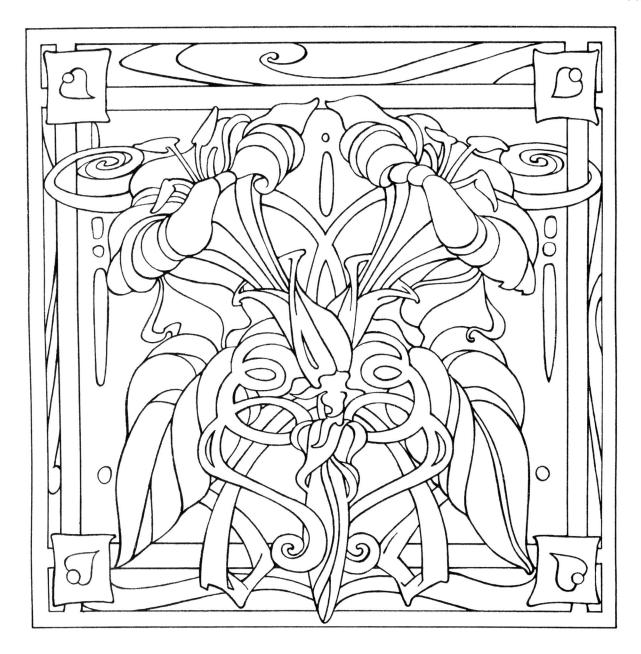

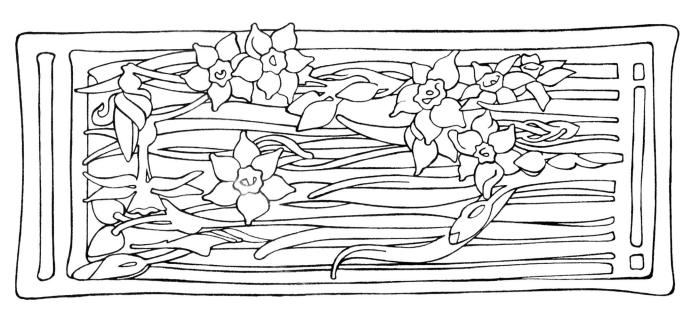

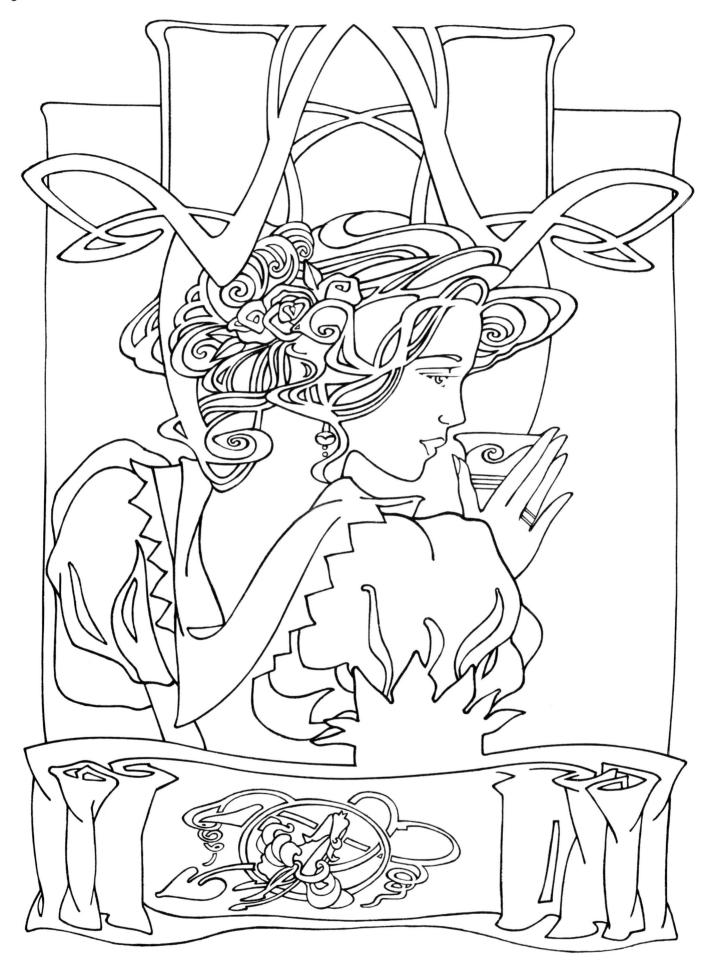

Figures

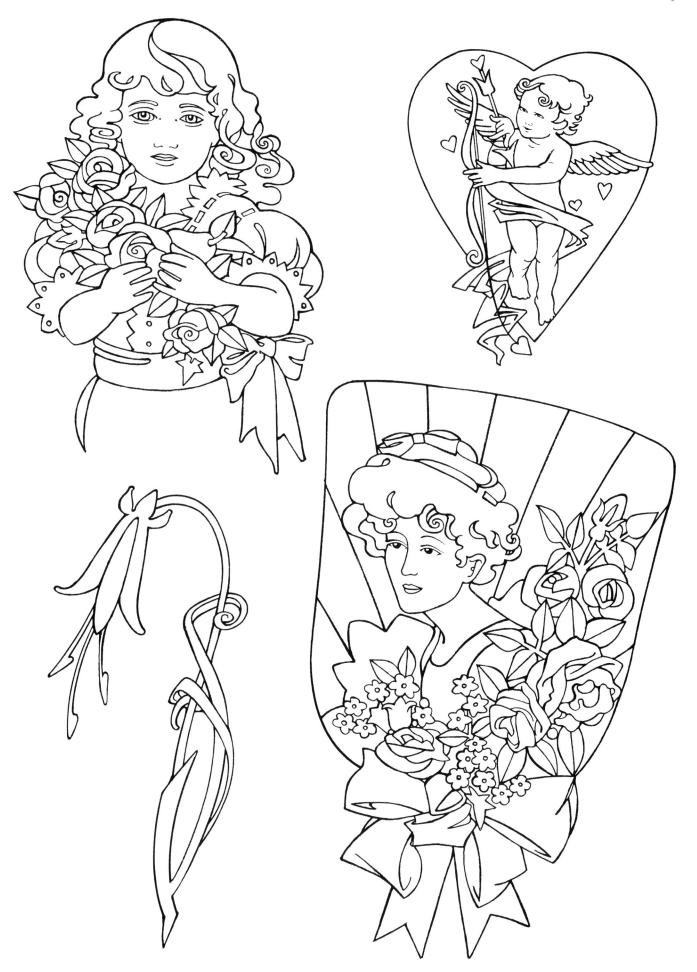

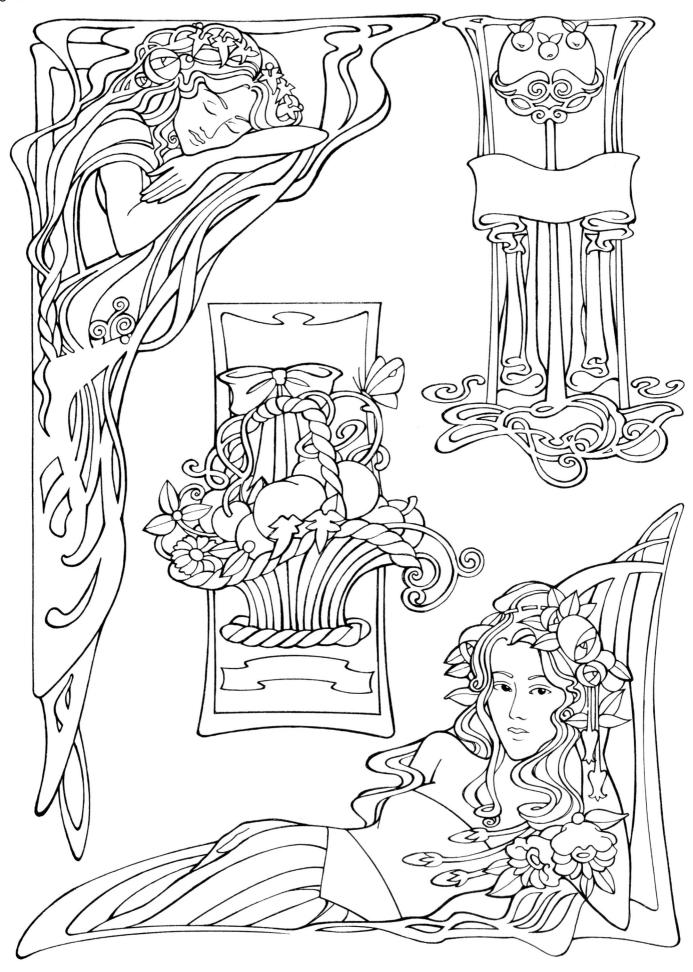

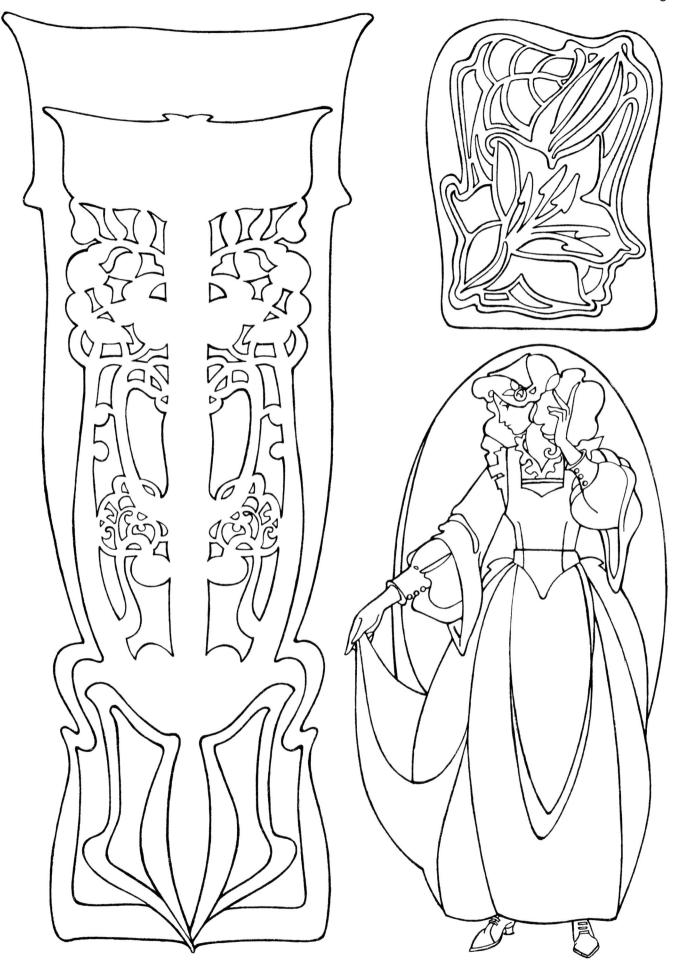

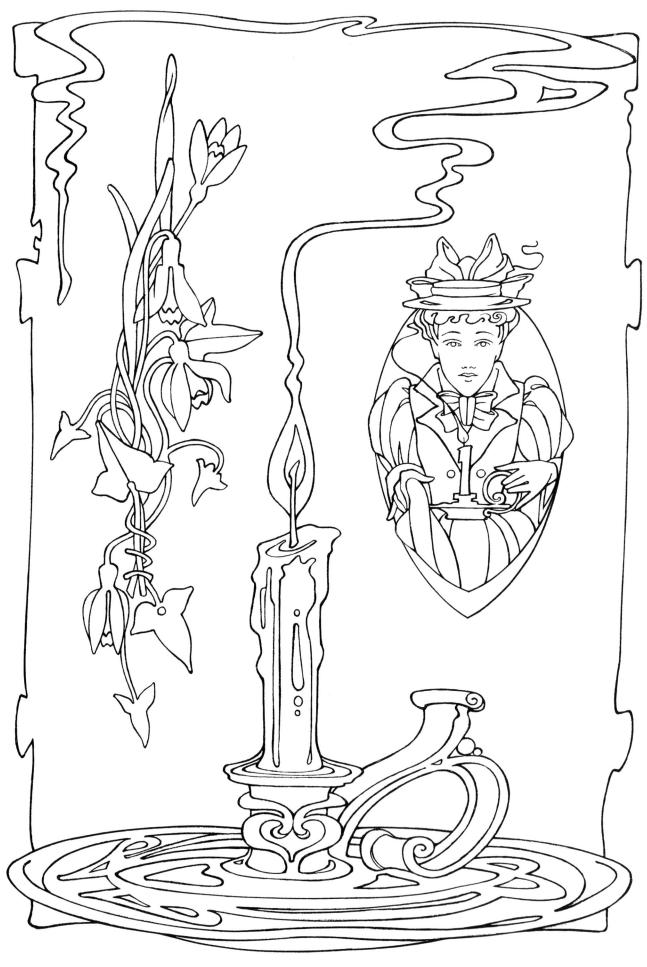

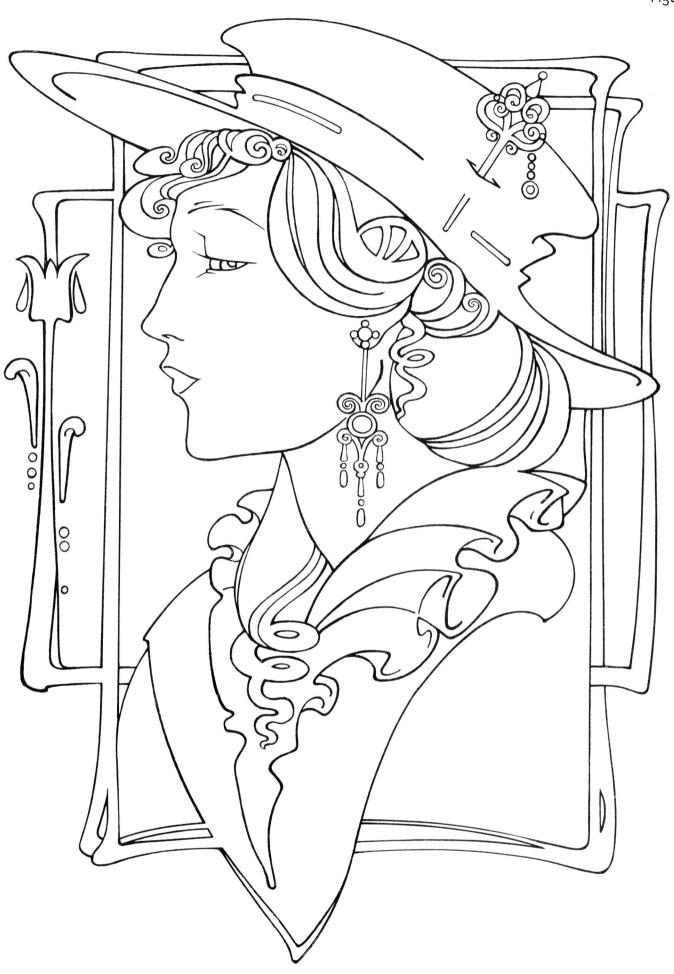

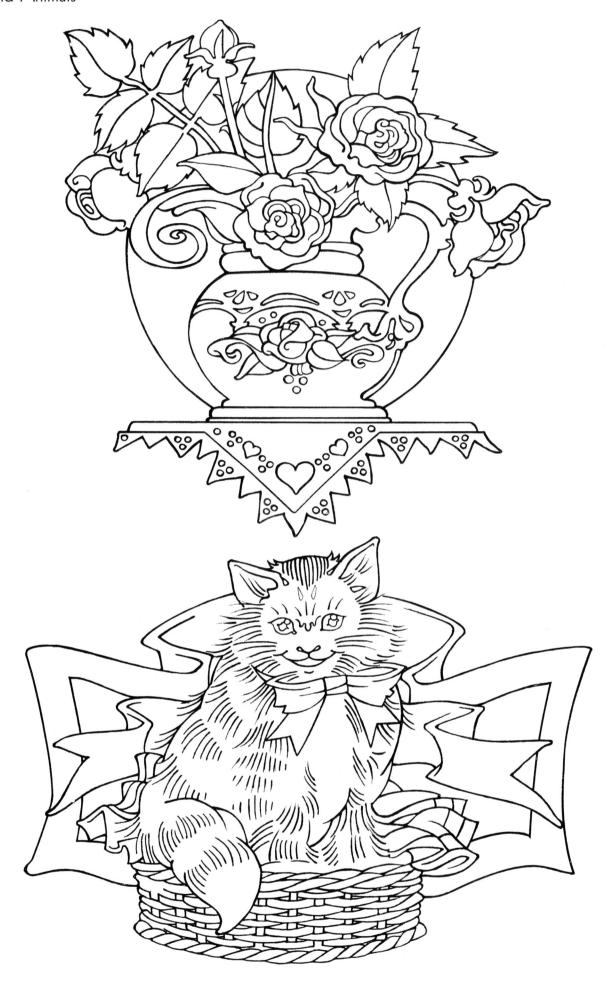

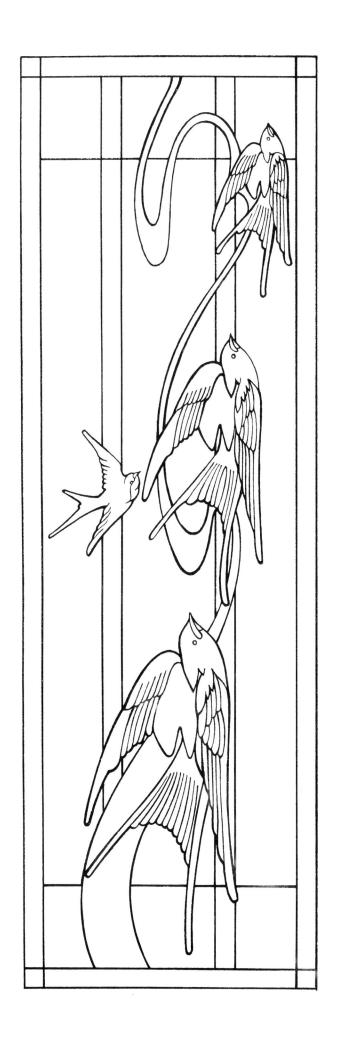

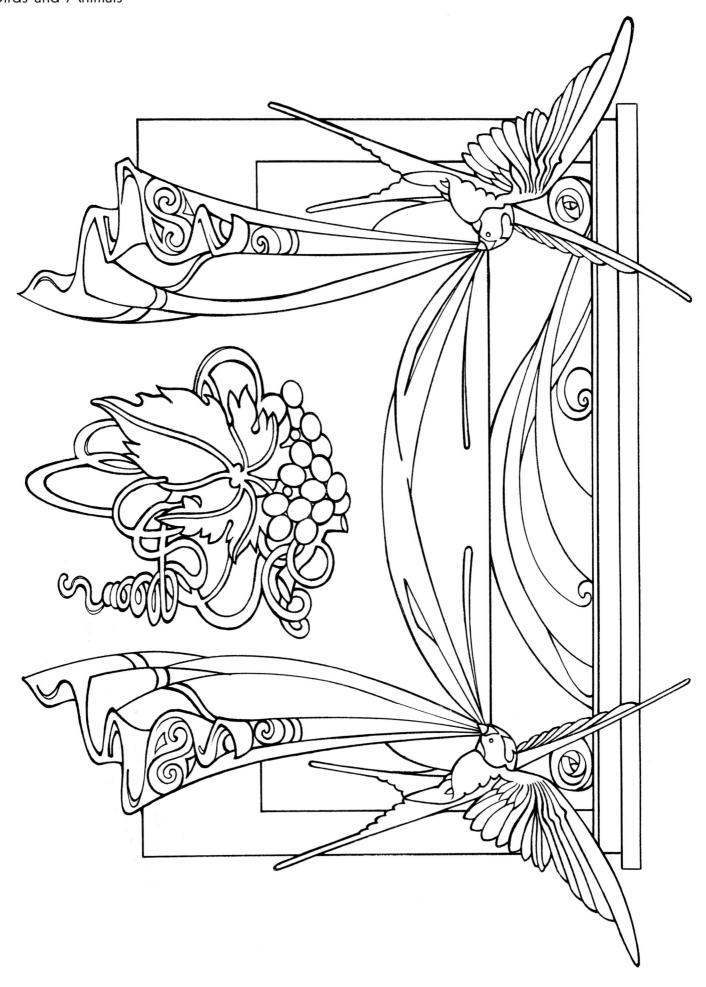

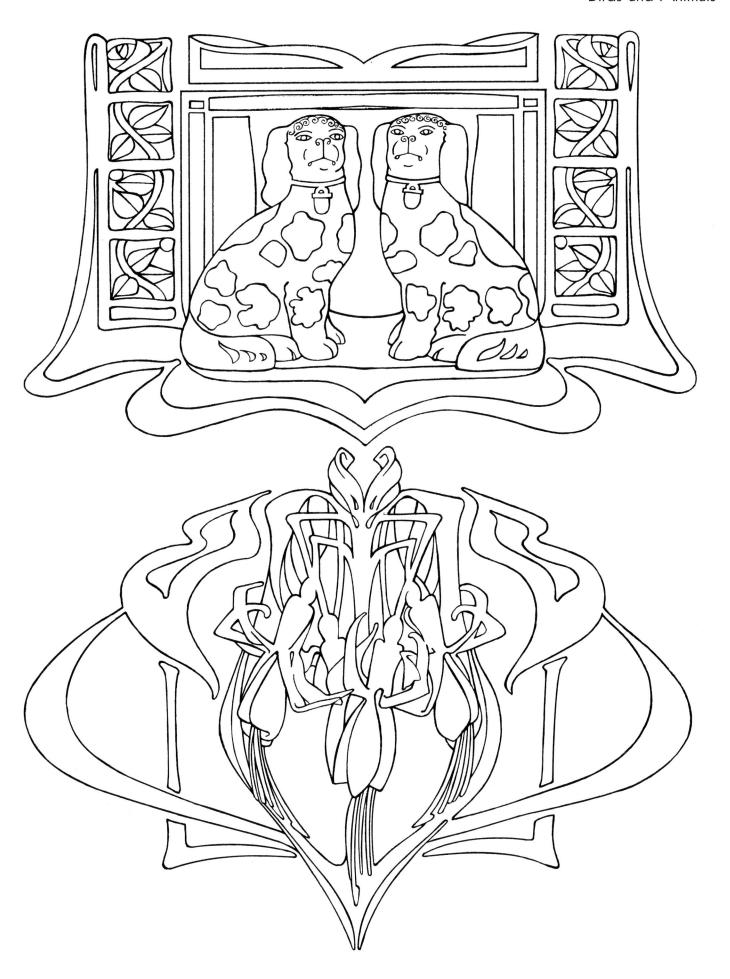

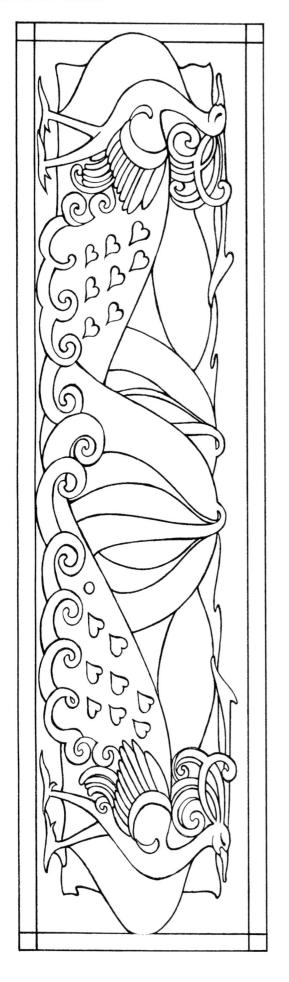

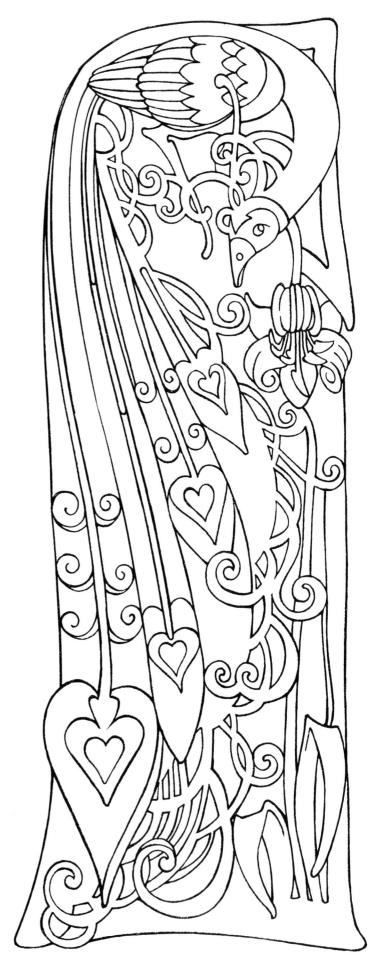

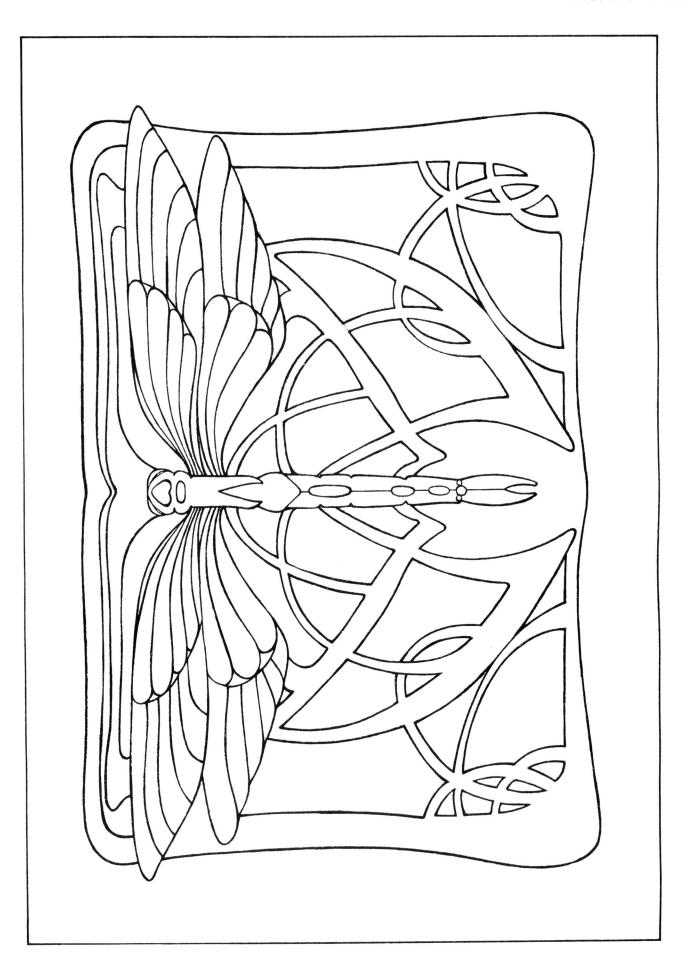